LIGHT IN THE DA

Louise T

All rights ᵣₑₛₑᵣ

Presentation by *BookLeaf Publishing*

Web: www.bookleafpub.com

E-mail: info@bookleafpub.com

ISBN : 9789394788220

First edition 2022

LIGHT IN THE DARKNESS

Louise Thraves

BookLeaf
Publishing

DEDICATION

This book is dedicated to my three children Bryden, Rowan and Kenya-Jordyn who pick me up unknowingly when days seem dark. They give me the hope of tomorrow and keep me busy everyday. X

I would also like to dedicate these poems to my late brother Kiefer Frary. Sadly no longer here but forever loved. X

ACKNOWLEDGEMENT

I wish to give thanks to my amazing, family for their continued support throughout my poem writing and always believing in me from the beginning. Thank you so much.

I'd like to give special thanks to my group of friends (you know who you are) for always giving me truthful feedback and always having words of encouragement. Thank you guys!

Lastly a big thank you to BookLeaf Publishing for giving me the opportunity to share my words with the wider world. Thank You.

PREFACE

My poem writing started back in 2013 when my younger brother Kiefer sadly passed away.

One day I took a pen and poems filled the pages in front of me. It became my way of letting go, releasing and become free again.

MIND

On the outside a woman.
Inside a small girl.
Its a way to hide feelings
From the outside world.

Bury pain deep down,
In a place that can't be seen.
So no-one gets to see,
How tough it has been.

Paint a smile on the lips
Place laughter in the air.
Cover up low points.
So no-one has to care.

Bottling things up.
Is a way to move on.
Must keep up pretence,
And look big and strong.

Pushing people away,
But wanting them by your side.
Wishing there was a switch,
To turn around the tide.

Emotions run high,
But don't let it show.

No-one needs to know,
Where dark thoughts go.

Go to bed at night.
No sleep to be had.
The minds does overtime.
Make believe that your mad.

THE GENTLEMAN, PRINCE & DUKE

You were born on the 10th of June in 1921.
With four older sisters, you were the only son.

A long life full of courage, bravery and charm.
We saw you marry the love of your life, and gain
a queen on your arm.

You fought in battles, that made history.
You weren't afraid of some hard graft.
You did your best to help many countries.
In the late present and the past.

You devised a plan of courage,
that helped your ship to sail away.
When the bombers invaded Sicily.
In them dark and awful days.

You were a sports enthusiast.
You liked to partake, in two or four.
From polo to carriage driving,
You were always eager for more.

Nothing seemed to faze you
or stop you in your tracks.
When you retired from royal duties.

It was never feet up and relax.

Seventy-three years of marriage,
Saw your love story span the years.
Supporting our Queen in every way.
Without question, hesitation or fears.

By a nation you'll be remembered as Prince
Philip.
Duke of Edinburgh you'll be thought of by
some.
No matter what your title.
You will always be our Queen's number one.

HANDS

Some hands were made for healing.
Some hands were made from gold.
Surrounding us with loving arms,
When we would start to fold.

Picking us up when we're down,
Or feeling low and blue.
Telling's us how much we are worth,
Even though we don't believe its true.

Supporting all our hopes and dreams,
Wiping away our pain.
Comforting us when days are dark,
And making us smile again.

These hands that I talk about,
Have been there from the start.
They have built me up to the person I am,
And have done it all from the heart.

These hands have carried far too much,
Throughout the span of time.
Its time to rest up now,
I will love and care for them with mine.

DAME VERA LYNN

She was known as the nation's sweetheart,
Lifting spirits where ever she went.
Bringing joy to the face's of thousands,
She was clearly heaven's sent.

Her songs sent out a message,
To the young and to the old.
The message was quite clear,
It was to have hope and not to fold.

She sang about the 'White Cliffs'
And all the beauty they possessed.
She sang 'We'll Meet Again'
She was simply one of the best!

She showed bravery and courage,
When the world was sent to fight.
Let her message uplift us once again
Dame Vera Lynn we bid you goodnight.

WONDER

I wonder how you sound.
I wonder how you look.
I didn't get chance to be your mam.
That fate wasn't in the book.

It doesn't stop me thinking.
What person you would have became.
What features you would have.
Or if we would look the same.

I didn't get to cuddle you.
Or kiss your sweet face.
But know I love you always.
Even though your in a different place.

I don't get to read you stories.
I can't tuck you into bed.
But with every passing day.
Your always in my head.

You'll never be gone from my memory.
In my heart you stay.
Missing you for eternity.
Forever and a day.

QUEEN'S 96TH BIRTHDAY

It started back in 1926
When Queen Elizabeth was born.
Little did she know back then.
In such a short time, she would take the throne.

Her reign defined by an oath that she pledged.
That to this day she has never broken.
A service upheld to the highest of standards.
Carried out with dedication, love, and devotion.

The first female of the Royal family,
To become a member of the Armed forces.
She is known by all for her love of animals,
Especially her corgi dogs and horses.

She describes her late husband as her Strength
and Stay.
A true love story that spanned through decades.
The longest marriage of a British sovereign.
A National treasure that will never fade.

This year marks another milestone achieved.
As our Majesty reached 96 years old.
Such a remarkable and courageous lady.
Her story will forever be told.

She wears a crown that sits upon her head.
She is known as the Queen to thee.
Ruler of our country.
Long live the monarchy

SIR CAPTAIN TOM

You fought for Queen and Country.
You fought for people like me.
I think I speak for everyone,
When I say we honour thee.

You lifted a nations spirit
By walking around your home.
You did it so gracefully,
Without a whinge or moan.

Sir Captain Tom you became known.
You showed us all you cared.
An internet sensation,
With a good few thousand shares.

You climbed the charts to number one.
With Michael Ball by your side.
Reaching that top spot
Filled us all with pride.

Gone but not forgotten.
You'll never walk alone.
In the arms of angels.
The good Lords taken you home.

DEMENTIA

I remember times from back in the days,
Memories from when I was small. When I could
learn life through play and fun was had by all.

I remember my teenage years thinking that I
knew it all. No one could tell me how or what
to-do. I was big and I was tall, and I knew
everything I needed too!

Then motherhood came I remember this well.
This part of life brought a whole lot of news.
From making bottles to cooking family stews.

The challenge has come since I've gotten a little
older. My hair has got grey and my skin thinner.
More lines have appeared and some days I don't
look that smart, but yet this is not the hardest
part.

My brain has slowed and my memory has
rusted. I might forget your name or forget who
you are. I don't do this on purpose my mind is
just ill. And sometime life just stays a little still.

They tell me its called dementia but I don't know what that means. All I know is that sometimes I may need looking after, but it doesn't need to be a disaster. Just sit with me today and listen to what I have to say.

Sometimes I do things differently, because my mind isn't really my own, but just think for a second... Do you never talk to yourself when you are alone?

MOTHER

This is for a special lady,
That I get to call my mother.
If I could have chosen,
I would have chosen no other.

You have given me so much,
All the love from your heart.
I treasure our time together ,
Cos It breaks me when we part.

I don't know how you done it all.
Be a cleaner, a cook and friend,
And when you had five minutes,
Lets me play and draw with you to no end.

You always put me first,
Without question or hesitation.
Your the strongest woman I know
My love for you has no limitation.

Your always there when I need you,
Your love is never short.
I know I can always come to you
If ever I need support.

ALWAYS MY BROTHER

You were my little brother.
Kiefer was your name.
Since you left this world behind.
Life has never been the same.

You are missed everyday.
By so many it would seem.
Whenever someone mentions your name,
Oh how my face doesn't half beam.

Everybody knew you,
All the girls and all the boys.
And when we all share memories,
It brings back so many joys.

"Have you got a fag en?"
Is what reminds us all of you.
Its the most common thing you said.
To everyone you knew.

So many precious photos,
Hang upon our walls.
If all our love could be measured,
It would fill a trillion halls.

You were so very special,

To everyone you met.
If love alone could have saved you,
Forever you would have been kept.

HOME

You were there when we took our first steps,
Stumbling, unsteadily around on the floor.
You guided and encouraged us,
Until our feet walked us out the door.

You showed us what it was,
To live life to the full,
Making our own decisions,
The strength of your love so powerful.

All the obstacles you over came,
We have nothing but respect.
You were, the strongest fighter
You really did give it your best.

And although we can not hear your voice,
Or see your smile no more,
We know you will walk with us,
Just like you did before.

Today we come to say farewell,
As this is not the end.
We will see each other once again
Until then our love we send.

For where you go you can be sure,

You will never be alone
For where you are is what matters most,
Because to us this will always be home.

MONSTER

Perfect to the world outside, no one could see
his flaws. His hands were meant to protect us
from people with these claws.

Turn down the music before he gets home, don't
want to cross the line, If we listen to his every
word we might all just be fine.

Slamming of the doors was just a common thing,
the thumping of my heart that is beating from
within.

The fear sometimes overwhelmed me, when I
saw him do more hurt. I saw him trashing up the
house and ripping up her skirts.

My brothers knew no better than to be a little
bold. They were only young in age and didn't
always do as they were told.

This will awaken the creature inside I simply
tried to say. We didn't want that to happen we
want this man to stay.

But the monster had taken over again, this was plain to see. Why couldn't he simply be the man that the rest of them can see.

THE MONSTER RETURNS

The monster has come back again,
Never too far away.
Why doesn't it just leave us alone
I want the kind man to stay.

He's a nice man when its not around,
Telling him to be mean.
Our family is such a loving one,
When the monster isn't seen.

She's not scared, she's use to it now
No fear is in her eyes,
But why does it come, I need to know,
So I can stop all of its lies.

The monster says it will go away,
Never to come again.
Then out of nowhere it raises its head
And it rages on again.

No one knows why it comes for us,
Spilling all its venom.
Harming everything in its sight
Its like a voice yelling 'go get them'

He is always sorry after its been.

Crying he doesn't know why.
She just nods silently.
With tears rolling from her eyes.

REMEMBRANCE

Today I met a gentleman,
As humble as can be.
He talked of much sorrow
Caused from such tragedy.

He spoke about Remembrance,
About the people that he lost.
About the sacrifices they made,
At such devastating costs.

I listened to his words,
As he recalled many of scenes.
Imagining the hurt he felt,
From the pain that he had seen.

Thankful is what I feel,
Towards the brave people, who serve in war.
Some never to return,
Nor see loved ones no-more.

Proud, honoured and inspirational,
Are a few words I would say.
For the people who served for us,
Forever remembered on Remembrance Day.

MY COUNTRY

Around these lands,
As far as the eye can see.
Mountains frame the views,
Of this beautiful country.

Green grass spans the fields,
Like carpet freshly laid.
Where daffodils bloom in spring time,
And the sheep like to graze.

Snippets of the mother tongue,
Can be heard here and there.
A true feeling of belonging,
Is felt in the air.

This country is home,
Its beauty is one to treasure.
A community like family,
Where everyone comes together.

LIGHT IN THE DARK

Within my mind there's sunshine,
Boxes filled with joy.
Memories full of happiness that spans the length
of time.

But then the dark days creep upon, And no light
can enter the room.
The boxes are filled with emptiness And the air
is full of gloom.

As the fight breaks out and the swords are
drawn, which one will win today?
Which one will strive above them all and come
out on top to stay?

Will darkness consume my thoughts or will
golden rays shine through? Will ugliness fill my
void or will my heart beat strong and true?

THINK

Sadness is all around us,
Its everywhere you look.
From stories on the news,
To headlines in a book.

But don't you think its time we stopped,
And had a little think.
Sit down with one another,
Talk over a drink.

Think about the way we act
Or the harsh things we may say. Kindness and
uplifting words,
Encouragement all the way.

Think about how your actions can impact others
too.
How it can make them feel so all alone, and
sometimes very blue.

Although there's a smile upon their face,
Sometimes that just isn't real.
Sometimes people hide away,
And don't really show how they feel.

They keep their pain from the world. And fight
their battles off the field.
They withdraw from everyone,
And put up a great big shield.

Like a slow erosion from themselves, Going it
alone.
Where all their thoughts and feelings,
Are left freely to roam.

When they want you to know,
But don't want to share.
Feeling like there's no escape,
Even though your right there.

So lets all spread some love and kindness.
Take a moment to reflect.
How our behaviour can affect others around us.
Stand up and do your best.

Think about what you say before you speak the
words.
Your action speak volumes, their echo's will be
loud.
So let all take a stand and make one another
proud.

THE YEAR 2020

The year 2020 was not what we had planned.
Work and schools shut down.
And more than 5-mile travel got banned.

Non-essential items were taken from the shelves.
No meeting with others just time by ourselves .

The virus swept over the land,
It changed the world we knew.
But it has taught us one thing though,
Which is how to learn and grow.

It has changed the way we think.
It has shown us who was really there.
It has made our hearts a little bigger,
It has made us show we care.

So many have suffered.
Lost loved ones, homes and jobs.
Trying to put the pieces back together.
Whilst holding back their sobs.

So lets come together
And help where we can.
Small actions of generosity
Can mean more than we plan.

LOVED ONES PASSED OVER

A new year has dawned.
Your memories I'll carry on.
With each mention of your name,
My heart will sing a song.

The festivities are over.
Another year come and gone.
Celebrating without you here,
Feels somewhat a little wrong.

I'll remember all the good times.
The fun we use to share.
The laughter that could be heard,
When we thought no-one was there.

Many loved ones have passed over,
Yet we will never really part.
Although they may not be here in persons.
They will stay forever in my heart.

I STAND WITH UKRAINE

Smoke fills the air, as the bombs hit the ground.
They keep on coming, no mercy to be found.

Family's are torn apart as the fight continues
some more. Another day, brings more heart
ache, and some hearts beat no more.

The bravery they show is seen by all. We look
on hopelessly, praying that they will not fall.

Frightened children ask unknowingly, what is all
this for? Yet nothing will justify, why Putin
started this war.

Innocent lives taken, soldiers gunned down in
the streets. Children separated from parents,
with no safe haven to sleep.

Food is running low, they have just the clothes
upon their backs. Everyday essentials these
people now lack.

Sirens sound loudly, over cries of the young. We
need to stand together and be united as one.

Teach children that this isn't the right way. Did we learn nothing from our ancestors back in them dark days?

Violence is never the answer to sorting our problems. We need to spread more love, and put down the guns.

Lets stand as one, show our support to the brave. Hope the war ends soon, with all innocents saved.

CHILDREN

If one day you wake up,
And find I'm no longer here.
I want you each to know,
I want you all to hear.

I love you all so very much,
With every beat of my heart.
I loved you from your first movements.
I have loved you from the start.

My babies when it gets to tough,
Listen to the voice inside.
The courage and the strength you need,
Is sometimes tricky to find.

You will get through,
Strive to the top.
Don't ever let anybody,
Tell you to stop.

All the power you every need,
Is deep inside of you all.
Just have confidence in what you want,
Take a stand and don't fear if you fall.

Just get back up, and try again.
Never give up on your dreams.
Remember one thing in life
Not everything is what it seems.

Look at things from a different view,
And then you might just see.
How wonderful life is.
And how simple it should be.